Monet

THE LIFE AND WORKS OF

MONET

Edmund Swinglehurst

A Compilation of Works from the
BRIDGEMAN ART LIBRARY

SIENA

Monet

This edition first published in Great Britain in 1994
by Parragon Book Service Limited

© 1994 Parragon Book Service Limited

ISBN 0-75251-518-7

Printed in Italy

Designer: Robert Mathias

CLAUDE MONET 1840-1926

Monet

A T FIRST GLANCE, Claude Monet's paintings seem rather superficial, a rendering of ephemeral effects of light under diverse weather conditions: sunlight on water, a breeze stirring the poplar trees, fogs in London, and morning, noon and evening light on Rouen Cathedral or haystacks.

Indeed, Monet has long been regarded, as Cézanne remarked of him, 'merely an eye, but what an eye', translating onto canvas the images before him. Cézanne was an intellectual painter, creating a theory which became the foundation of modern art; when he called Monet merely an eye he did not mean the mundane eye through which most of us see the world. Monet's eye was a painter's eye, an eye with a creative mind behind it, interpreting apparent reality and putting it into the context of the thoughts in the painter's mind, thus creating a new vision for the spectator.

Monet's approach to the visual world was along Venetian lines rather than Florentine; he interpreted the world through colour rather than drawing. His ancestors are Titian and Claude, not Michelangelo and Poussin. Like his predecessors, he discovered that colour has its own reasons just as drawing has, and that they are opposing forces; too much drawing inhibits colour, and colour breaks the clear demands of line. Monet sought for the true reality behind an apparent reality of visual appearance by stretching colour to its limits and looking for those significant nuances of colour which express the reality of the world in nature itself.

Claude Oscar Monet was born in Paris on 14 November 1840. His father was a grocer and wanted his son to follow a profession. Fate

decreed otherwise. When Monet was five the family moved to Le Havre, a bustling seaport on the mouth of the River Seine near the spectacular white cliffs of Etretat and Fécamp. The young Monet was excited by the movement of shipping and the various moods of the sea – they appealed to his own naturally volatile and emotional temperament.

In his late teens he met Eugène Boudin, a painter who kept an artist's colour shop at Honfleur. Boudin saw some of young Monet's drawings and encouraged him to paint and, what's more, to paint in the open air, a method not much in use at a time of studio painters.

Fired with the idea of becoming a painter Monet went to Paris where he first joined the Académie Suisse and the Gleyre studio. Both places were seedbeds for a new generation of painters and here Monet met Bazille, Pissarro, Renoir, Sisley and others, the last two of whom became lifelong friends.

In 1870 Monet married Camille Doncieux and they went to Trouville for their honeymoon. While there, Monet went on a trip to Le Havre and, for reasons that no one has been able to explain, but was probably concerned with a fear of being conscripted into the French army, left for England on the outbreak of the Franco-Prussian war. His wife had to be rescued by Boudin and sent after him.

In London, where Pissarro had also fled, Monet painted his first London scenes. The war over, Monet and his wife returned to France in 1872 and set up house near Paris, on the Seine at Argenteuil. Here, Monet began a fruitful period of painting and of discussions about art with his friends Renoir, Manet and Sisley. In 1878 he moved again to nearby Vétheuil. It was here that Monet became friendly with a rich businessman, Ernest Hoschedé and his wife Alice, who became admirers of Monet's paintings. When Hoschedé's business went under he disappeared, leaving his wife and children with the Monets.

The following year Monet's beloved wife Camille died of tuberculosis just months after the birth of their second son. Monet recorded her deathbed in an extraordinary picture. After her death,

the restless Monet travelled extensively to the French and Italian Rivieras, to Normandy and the Atlantic coast of France. Wherever he went, he painted, but he was not content with his work. Different subjects were not the answer; all that mattered was the painting itself, the significance of reality through colour.

Monet eventually returned to the countryside near Paris, renting and then buying a house at Giverny where he set about creating a garden that he could paint in. In 1891, he began to paint his famous series of haystacks in the surrounding countryside, at all times of year and every kind of weather A year later he began his equally famous series of paintings of Rouen cathedral. At the same time, there were many paintings of his beloved garden at Giverny.

Alice Hoschedé had been sharing his life for many years: his letters to her about his painting excursions and his fears and hopes providing a wonderful insight into the artist's mind. When her husband died in 1892, Alice and Claude married.

Monet now entered a happy and productive part of his life. His work was accepted by the official Salon and he was not short of money. There were trips to Norway, Venice and London, but his home, both domestically and artistically, was at Giverny.

Alice's death in 1911 left him lonely and bereft and he was having trouble with his sight. After a cataract operation and special glasses he was able to continue work and was encouraged by Georges 'Tiger' Clemenceau to complete the great water-lily series which was acquired by the French state. Although now acclaimed as a great French painter, Monet himself, like most artists, never felt that he had achieved the perfect conclusion of the ideas that were in his mind. He died on 6 December 1926.

▷ **The Point at Heve, Honfleur** 1865

IT WAS AT HONFLEUR in 1858 that the young Monet met the painter Eugène Boudin, who encouraged him to take up painting in the open air. Boudin was older than Monet by some twenty years and no doubt the young Monet was flattered by Boudin's interest. In later life he told the critic Gustave Geoffroy that he regarded Boudin as his true master. In this painting one can detect the first tentative steps of the young Monet towards the freedom of direct open-air painting.

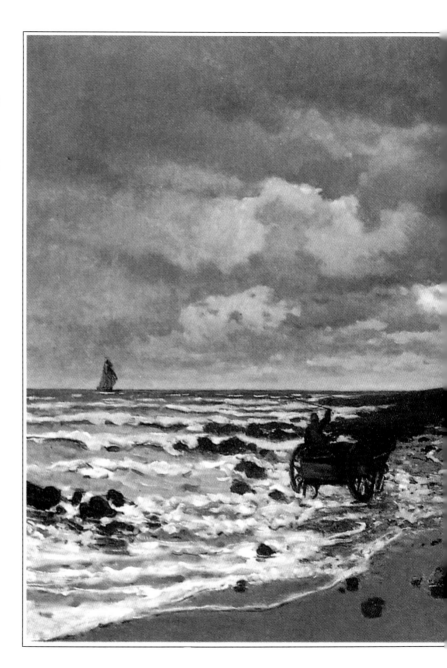

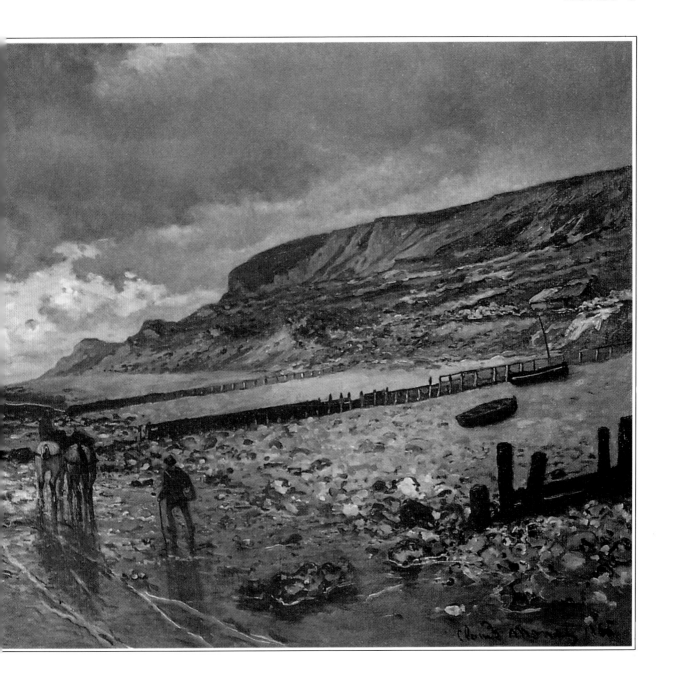

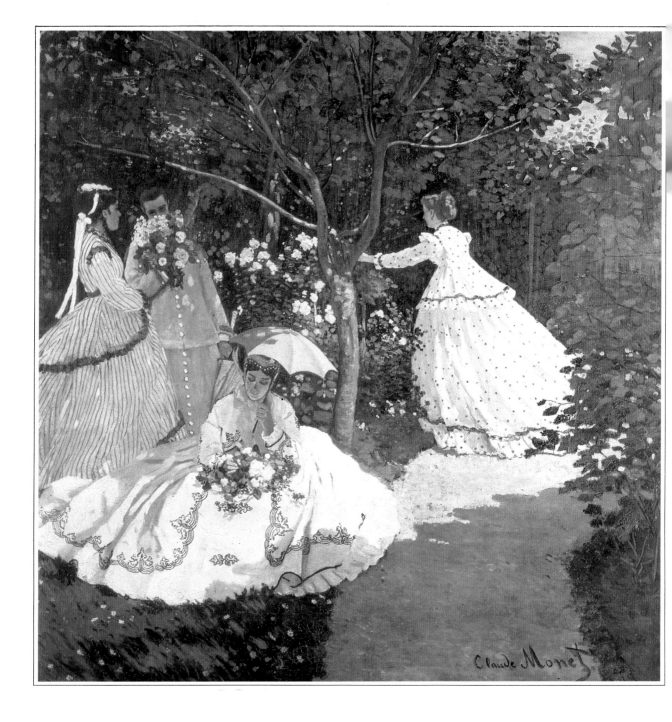

◁ **Women in the Garden** 1866

Oil on canvas

ALTHOUGH THIS PAINTING is more academic in approach than his later work, Monet has nevertheless imbued it with a bright, airy feeling far removed from the formal, brown paintings which were the accepted fashion of the day – a fashion which clearly prevailed among the hanging committee of the Salon, which refused this beautiful work in 1867. Despite its size, Monet insisted on painting it entirely out-of-doors and always in sunlight. Using his mistress, Camille, later to become his wife, as model for all four women, Monet worked on the painting in the garden of a house he had rented at Ville d'Avray in 1866.

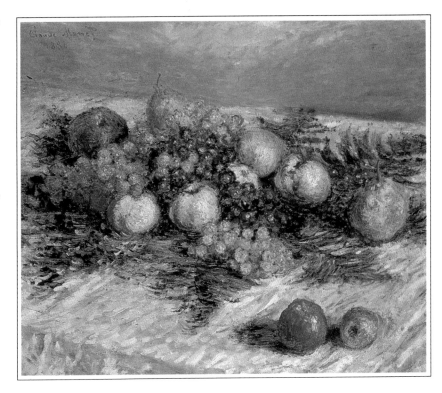

△ **Pears and Grapes** 1880

Oil on canvas

MONET WAS AN ARTIST who was stimulated by the sensual pleasure of things seen – the sunlight on the sea, the shimmering colours of rivers, the glare of the hot sun on the Mediterranean towns, red poppies in a field. He preferred too, a larger view than that offered by still life. Even so, it seems odd that he did not paint more still life, especially of such delightful subjects as fruit and flowers. In this painting of pears and grapes there is the pleasure of seeing the golden glow of the skins of the fruit suggesting the juicy contents.

▷ **Camille, or
The Green Dress** 1866

Oil on canvas

CAMILLE WAS STILL MONET'S mistress when she posed for this painting, in which the artist intended to portray a typical Parisian lady. In fact, as the work progressed, more interest focused on her face, turning the picture into a portrait. A prize-winner at the 1866 Salon and Monet's first public success, the painting was sold to Arsène Houssaye, who intended to bequeath it to the Luxembourg Museum. Later, Houssaye's son sold it for what Monet called a 'derisory sum of money'. When it finally came into the collection of the Kuntshalle at Bremen, Monet was delighted and wrote to the museum to say so.

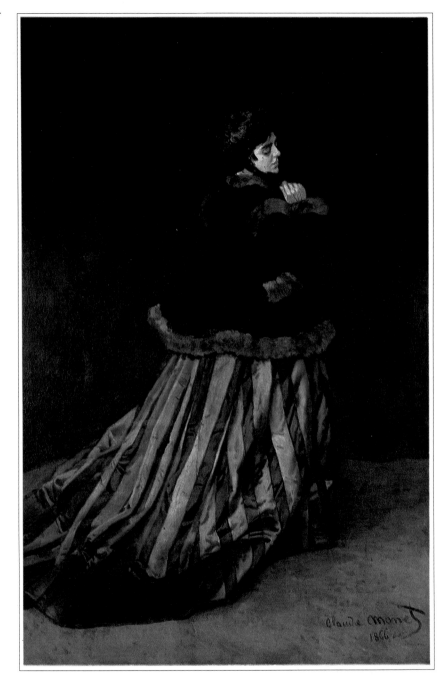

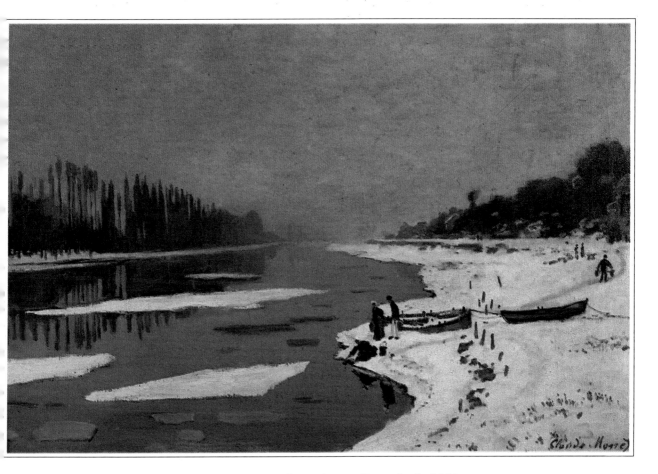

△ **Ice on the Seine at Bougival** 1867

Oil on canvas

MUCH LESS WELL-KNOWN than Monet's 1880 series of paintings of ice breaking up on the Seine, this painting is thought to have been done in the late 1860s, during a brief visit to the small village near Paris. For most critics, its great interest lies in the obvious influence of Japanese prints on the artist, who had been studying a friend's large collection of Japanese art. There are none of the horizontal and vertical brush strokes which characterize the 1880 paintings.

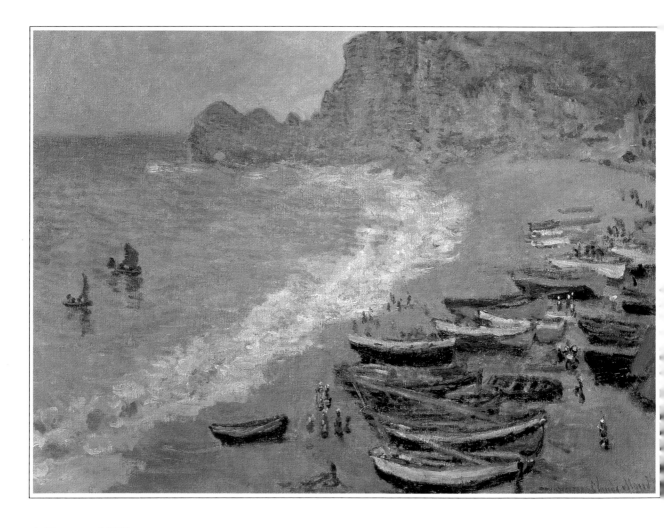

△ **Etretat** 1867

Oil on canvas

THE COAST OF NORMANDY around Etretat and Fécamp, with its white cliffs and changing weather, was a favourite of Monet, who had lived for many years at Le Havre. It also meant a good deal to him because it was along here at Pourville that, encouraged by Boudin, he had first launched into painting in the open air. This scene of boats drawn up on the beach is particularly delightful as a record of the simple life of fishing villages at a time when industrial life was beginning to destroy them.

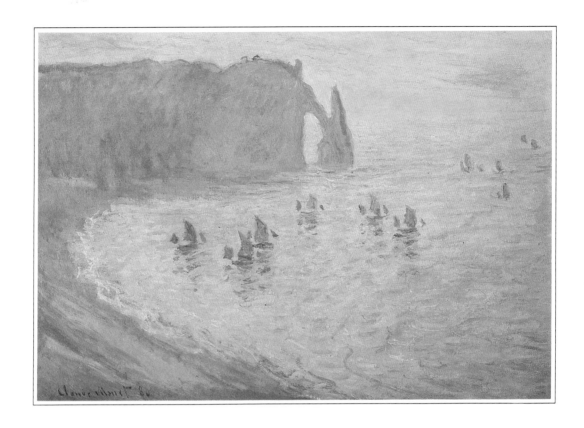

△ **The Cliffs at Etretat** 1886

Oil on canvas

ON ONE OF HIS VISITS to Etretat Monet was nearly drowned as he worked along the bottom of the dramatic cliffs. Under the impression that the tide was going out, he had placed his easel near the sea's edge, ignoring the breaking waves a few feet from where he stood. Suddenly a large wave swept round him, knocking him and his easel flying. Monet lost his balance and was dragged down the shelving beach. 'My immediate thought was that I was done for,' he wrote to Alice, 'as the water dragged me down, but in the end I managed to clamber out on all fours.' When he had recovered from the shock Monet's first thoughts were for his easel and paints without which he could not work.

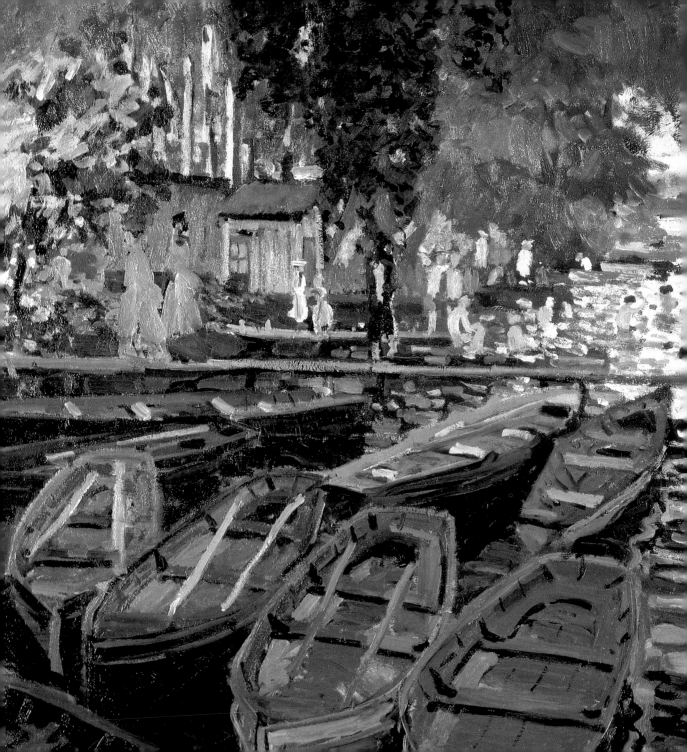

◁ **Bathers at La Grenouillère** 1869

Oil on canvas

LA GRENOUILLERE was a floating café and bathing place on the backwater of the Seine, near Paris, where Monet and his friends would meet to enjoy the amenities and, no doubt, the pretty girls who also frequented this pleasant spot. Renoir often accompanied Monet to La Grenouillère and one can imagine that the two good-looking young painters had a good time. They both produced delightful paintings of the scene.

▷ **The Promenaders
(Camille and Bazille)** 1869

Oil on canvas

THE PAINTER Jean-Frédéric
Bazille, killed in the Franco-
Prussian War, was a good
friend of Monet's from the
days of Gleyre's studio, and
their friendship continued
after Monet married Camille.
In painting them together,
Monet perhaps wanted to
demonstrate the affection in
which he held them both.
Camille and Bazille were
people on whom he
particularly counted when
things were not going well,
and he recognized the value of
their moral support.

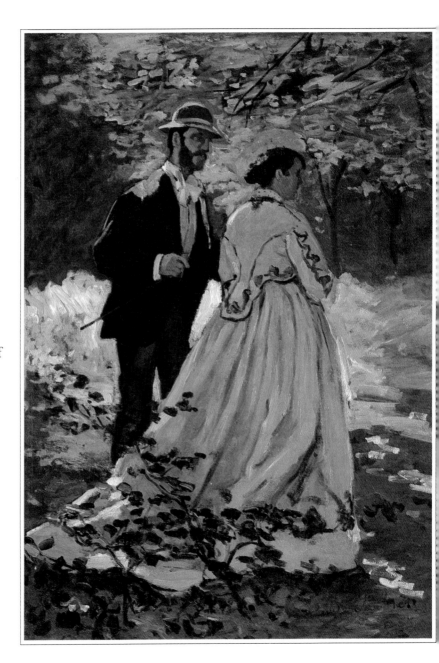

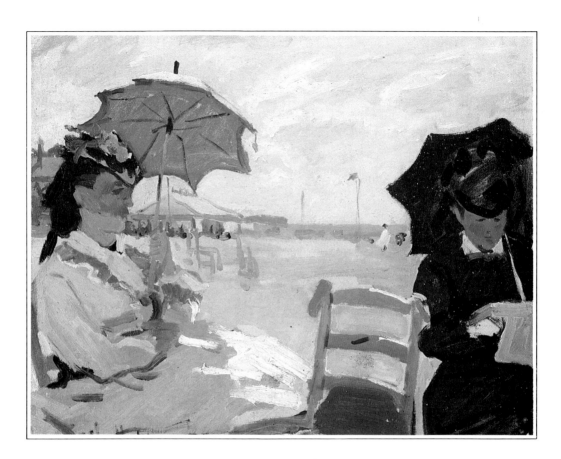

△ **The Beach at Trouville** 1870

Oil on canvas

GRAINS OF SAND from the beach still adhere to the paint on this evocative sketch of the town where he and his wife Camille honeymooned. The painting shows Camille and, perhaps, her sister (in the dark dress). They are doing what most people have done and still do on beaches, sheltering from the hot sun under a parasol and reading a book. The painting is one of several seaside scenes which Monet painted at the Normandy resort in the summer of 1870.

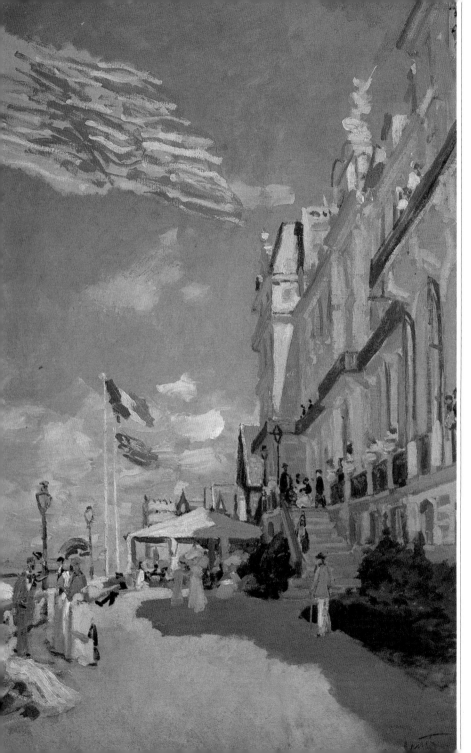

◁ **The Hotel des Roches-Noires at Trouville** 1870

Oil on canvas

WHEN HE SET OUT to capture in paint the effect of light and shade on the magnificent façade of Trouville's grandest hotel, Monet could have had no idea that he was depicting the dying moments of the Second Empire. He was still at work in Trouville when the Franco-Prussian War broke out in July 1870, but he did not at first appreciate the gravity of the news. It was only when he went to Le Havre in search of information that he realized that he might well be conscripted into the army. He fled to England from Le Havre, leaving his friend Boudin to gather up Camille and his son, Jean, and send the two to join him in England.

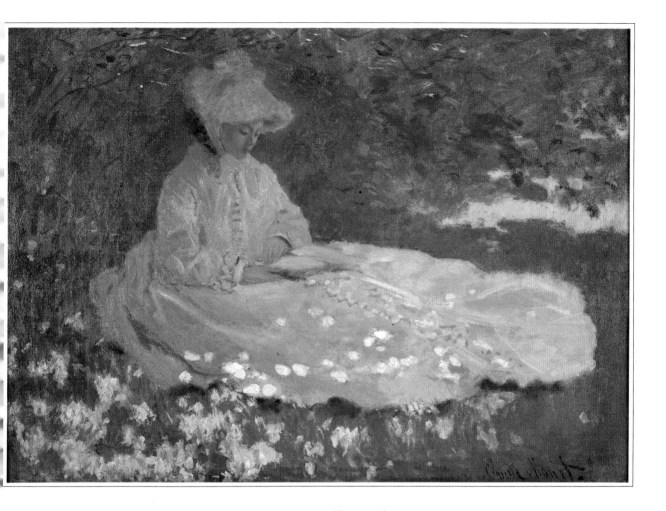

△ **A Woman Reading** 1871

Oil on canvas

THE WOMAN IS CAMILLE, sitting in the shade of a tree with her dress spread out around her, making a tender contrast to the green grass. The rendering of shadows was a special challenge to the Impressionist painters: they could not, as artists had in the past, simply indicate shadow by chiaroscuro, but had to find a way of depicting shade while retaining the luminous quality of the paint.

▷ **The Thames below Westminster** 1871

Oil on canvas

MONET AND PISSARRO both took refuge in London from the Franco-Prussian War of 1870-1 and the terrible siege of Paris which came at its end. While Pissarro painted the suburban delights of south London, Monet chose to work among the great sights of Britain's capital. Even London fog became an inspiration. In this painting, the Houses of Parliament and Westminster Bridge have become insubstantial silhouettes in the yellow fog, looming up behind the more definite forms of the jetty and figures in the foreground. 'I did an impression of it,' Monet wrote to his friend Alice Hoschedé, 'which I don't think is bad.'

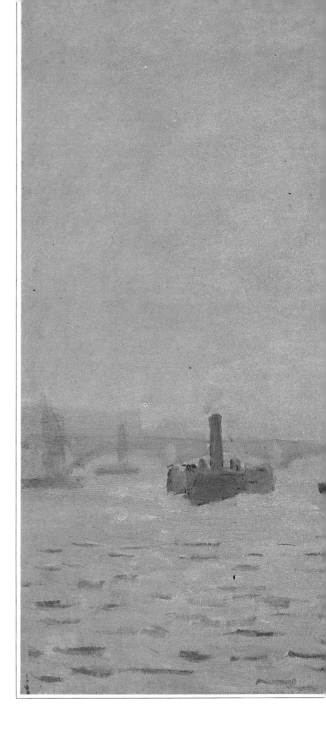

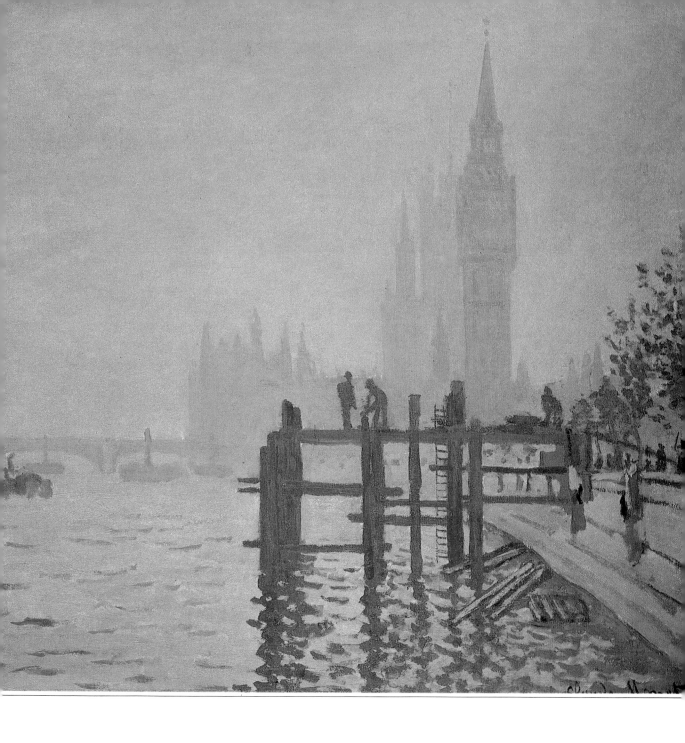

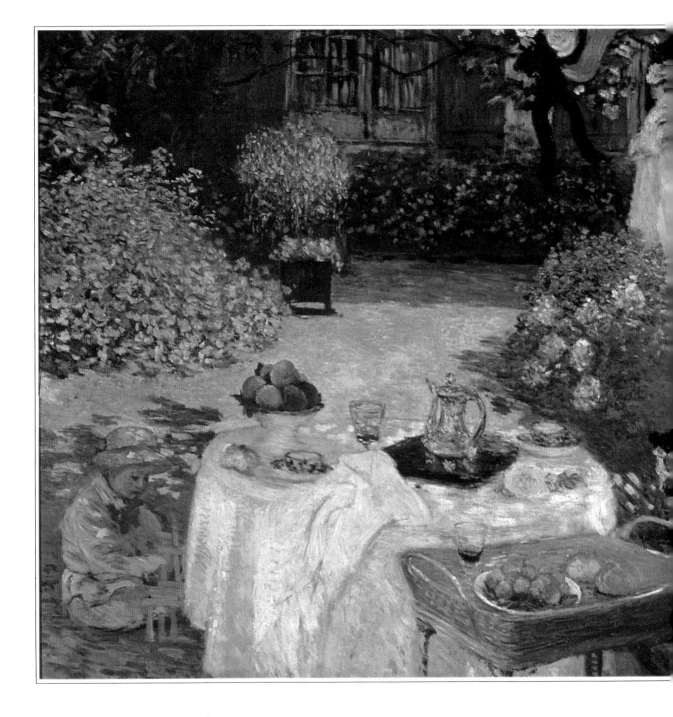

◁ **Le Déjeuner** 1872

Oil on canvas

THE LUNCH TABLE set out in his garden suggests to Monet a tempo and style of life which is idyllic. Despite the struggles with the actual technicalities of painting, and the exasperating gap between concept and execution, many of the Impressionist painters had a pleasant life, escaping to some rural haven such as this to paint from nature, and leaving it to their dealers in Paris to work out how to sell their work. This painting was included in the Impressionist group's second exhibition in 1876, and was quickly bought.

Falaise à Varengeville 1872

Oil on canvas

▷ *Overleaf pages 26-7*

UNLIKE CÉZANNE, who sought the permanent structure of the world, Monet was fascinated by its flux and flow: in this sense he was perhaps in tune with modern theories of the world. The solid world might be an illusion but it was the only means by which one could find out what reality was about. Like a scientist, Monet was trying to pin down the fleeting moment in order to discover a universal truth.

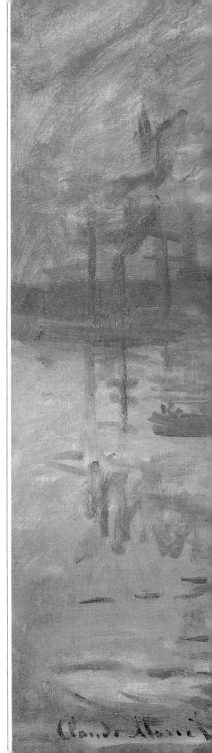

▷ **Impression – Sunrise** 1872

Oil on canvas

THIS IS THE PAINTING that gave the name 'Impressionism', originally used in critical terms, to the work of the revolutionary young painters who were breaking with academic tradition in France in the 1870s. It shows the sun breaking through mist over the harbour at Le Havre. To conservative art-lovers the idea of painting in the open air was new; they were unaccustomed to seeing the natural colours of the world about them used in art, which they thought should be a sombre and dignified business. They were also shocked by the sketchy and spontaneous quality of paintings that tried to catch a fleeting moment.

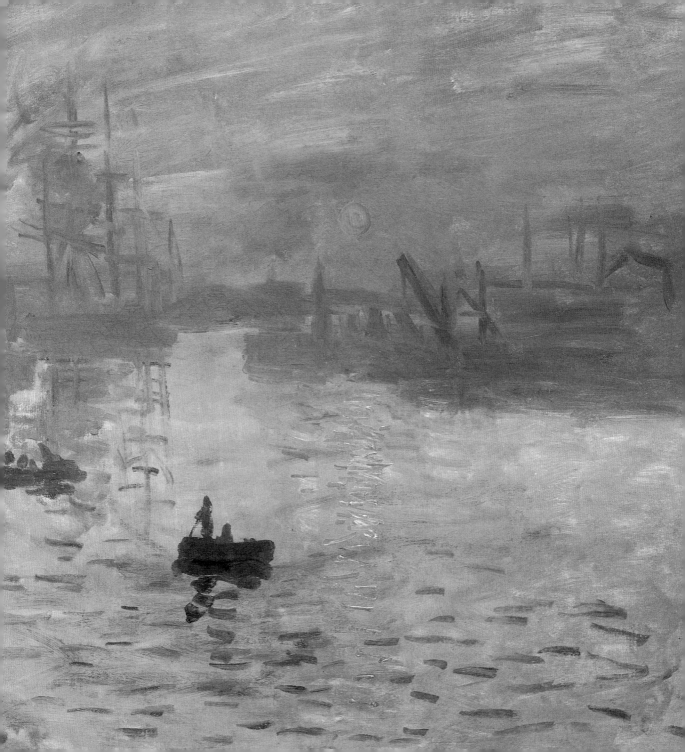

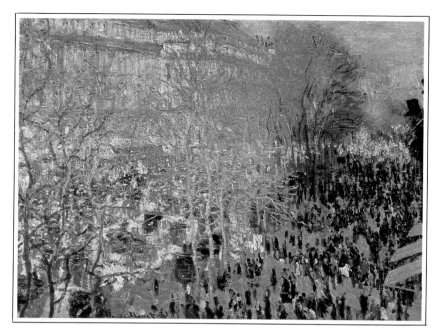

△ **The Boulevard des Capucines** 1873

Oil on canvas

AFTER THE FRANCO-PRUSSIAN war and the civil war of the Communards, Paris experienced a new beginning. The young painters soon to be termed 'Impressionists', came back from abroad or from the country, Monet reaching Paris from Holland in 1872. Life was hard for most of them. The conservative members of the French art establishment did not take to their art, and many of their painters were rejected by the Salon. In April 1874, a group of artists, including Monet, Pissarro, Renoir, Degas, Sisley and Berthe Morisot, exhibited independently in the Boulevard des Capucines. The exhibition was a financial flop and a critical failure. Another of Monet's paintings in the exhibition, a version of the Boulevard des Capucines which is the subject of this painting, was criticized for the way in which the crowds walking along the boulevard looked like 'innumerable black tongues'.

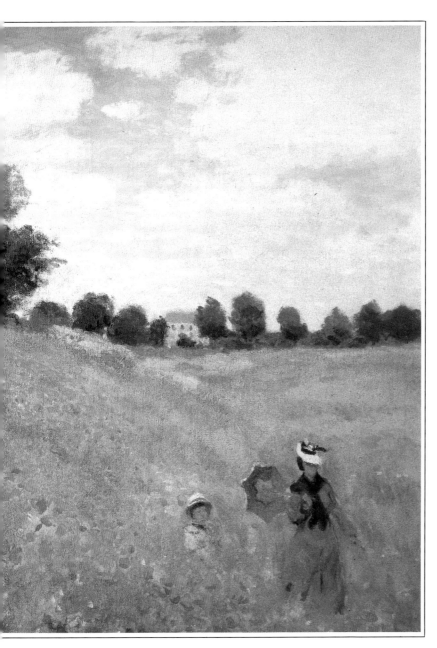

◁ **The Poppy Field** 1873

Oil on canvas

THIS PAINTING, which has been called a 'jewel of Impressionism', was among those exhibited by Monet at the first Impressionist exhibition in 1874. It was painted during a wonderfully fruitful period when Monet and his family were living at Argenteuil on the Seine near Paris. The red poppies make a fine contrast with the violet and green of the rest of the picture; the figures walking through the grass add a human dimension, unusual for Monet who often omitted it from his colour symphonies. The figures are Camille, Monet's wife, and their son Jean. The house in the distance may be Monet's own home at Argenteuil.

▷ **The Seine at Argenteuil** 1873

Oil on canvas

IN 1872, MONET had moved to Argenteuil, a village on a broad and attractive stretch of the Seine near Paris. There, his house became a meeting-place for his contemporary young artist friends. Manet, Sisley and Renoir were frequent visitors and Degas and others also dropped in to discuss the ideas and theories about painting that they shared. It was in this riverside haven that Monet reached a new stage in his work, painting many of his most famous works. To be able to study nature at first hand and without disturbance, Monet built himself a studio-boat in which he toured the river, anchoring whenever he saw anything that interested him.

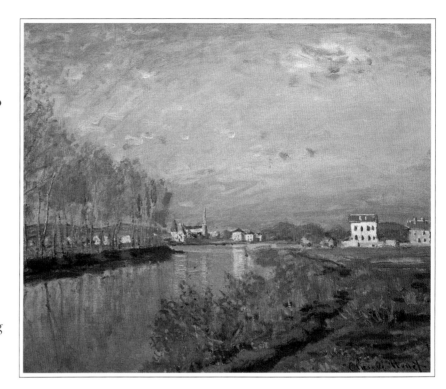

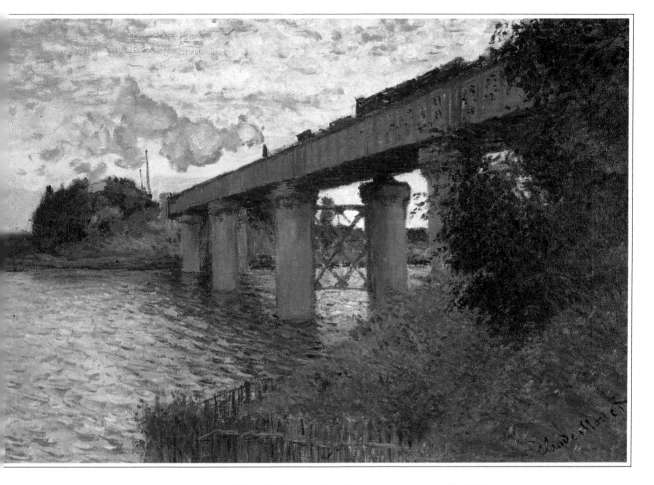

△ **The Railway Bridge at Argenteuil** 1874

Oil on canvas

AN IRON RAILWAY BRIDGE might not seem to have the same charm as yachts or jolly lunch parties, but for many people in the 19th century railways had the charisma of a new and exciting form of transport. In this picture, Monet used the bulk of the railway bridge to give weight to the picture, making a striking contrast with the peaceful river flowing beneath. He also used to great effect the way in which the light filtered through the train's steam and smoke.

▷ The Boats: Regatta at Argenteuil 1874

Oil on canvas

MONET PAINTED several scenes of boats at Argenteuil in the 1870s, most of them sunny scenes in bright colours. Here, for a change, he has chosen a grey, windy day, bringing out the delicate blues and greys which depict almost imperceptible variations of light. The broken clouds in the sky are reflected in the choppy, wind-blown water. The warm tones of the houses and sails across the centre of the picture provide a touch of warmth and contrast in what would otherwise be a rather cold painting.

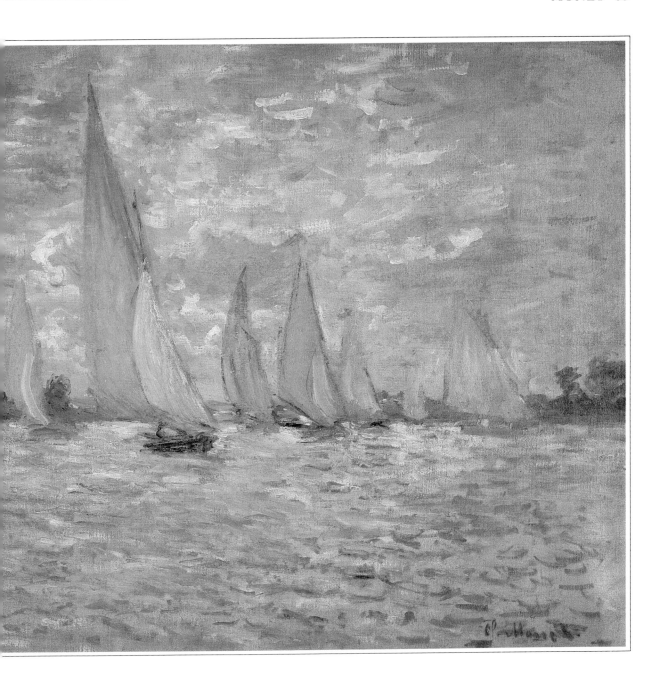

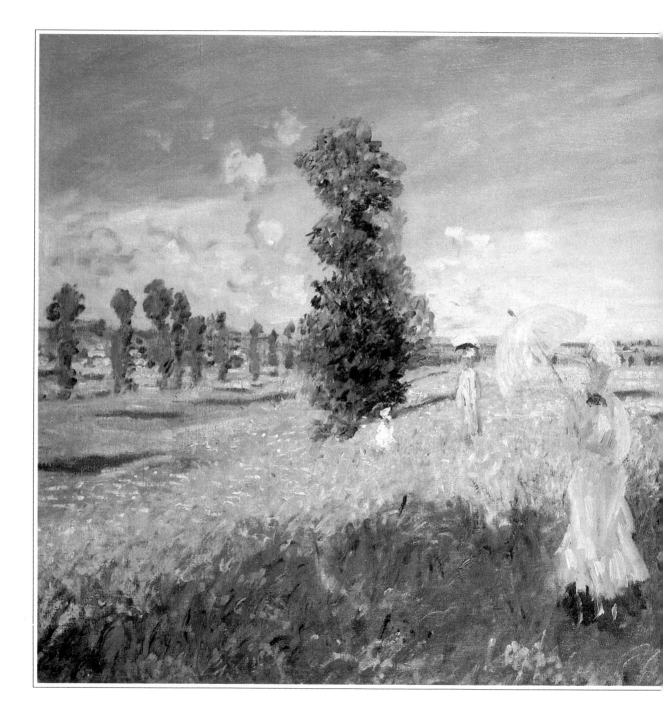

◁ **The Walk, Argenteuil** 1874

Oil on canvas

THIS PAINTING DATES from the fruitful period at Argenteuil in the 1870s when painting and family life both gave Monet immense pleasure. The people going for a walk here include Camille and their first son, Jean. Despite its closeness to Paris, the countryside was then still very rural. Argenteuil, which can be seen on the left behind a row of poplars, was then still a village, not the suburb of Paris it is today. Monet's rapid painting style can be seen here in the quick brushstrokes which describe the grass and the foliage of the trees. Like van Gogh, also a fast worker, Monet was able to catch the impression of colour and movement and put it down without hesitation, thus giving a unique spontaneity and freshness to his work.

Detail

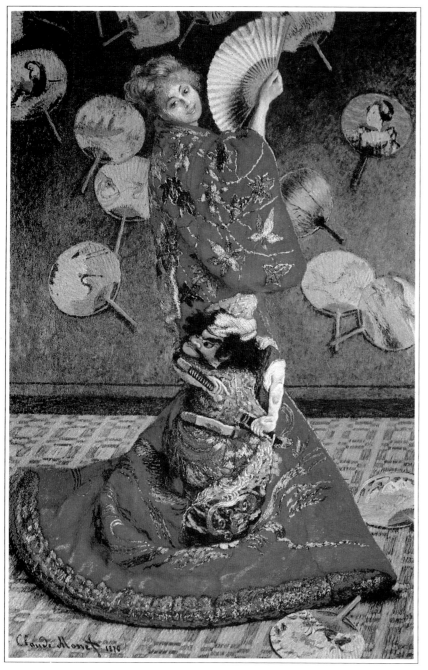

◁ **The Japanese Girl** 1876

Oil on canvas

ALTHOUGH MONET'S interest in Japanese art and culture apparently provided the subject, his way of painting it was perfectly European, even academically so. The picture made a surprising contrast with Monet's other work of the period, which included many sun-lit scenes of the Seine at Argenteuil. Here, the pose, by one of his regular models, is very studied and the arrangement of fans on the wall and floor has evidently been made with an eye to the composition.

▽ **The Gare Saint-Lazare** 1877

Oil on canvas

SAINT-LAZARE WAS THE station terminus for north-east France and the Channel ports. Monet himself used the station on his trips to Normandy and to England. Struck by the effects of the light filtering through the glass roof and the puffs of smoke from the engines rising and dissolving like clouds, he was inspired to do a series of paintings of the station. His friend Emile Zola approved of this painting because it showed that the artist was discovering 'the poetry of stations'. Unlike other painters of his time, though, Monet's interest was in the people who used them: the figures here are sketchily indicated.

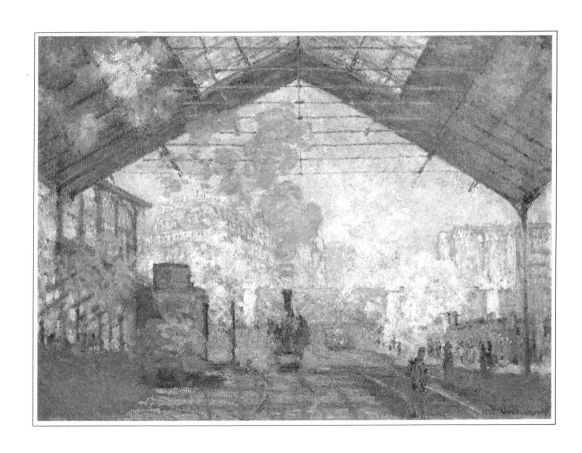

▷ The Fourteenth of July (Bastille Day) 1877

Oil on canvas

UNLIKE MOST OF MONET'S later work, though bearing some relationship to his scenes of the Grands Boulevards of Paris, this painting seems a spontaneous reaction to the patriotic content of Bastille Day. Here are the people looking in towards the centre of interest, and the *tricolore* which enshrines every Frenchman's patriotic image of La Patrie. Like Renoir, Monet was a true patriot, and wanted to achieve recognition not just as a painter but as a French painter.

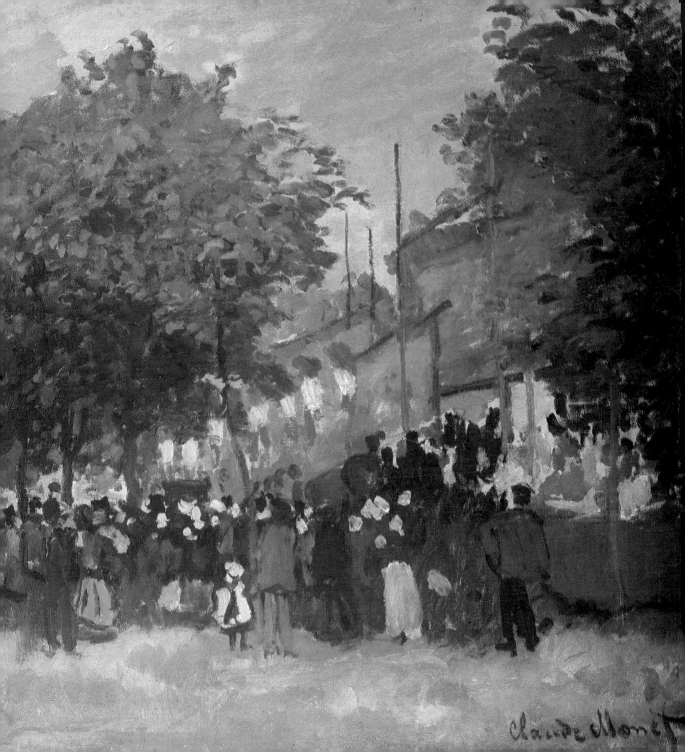

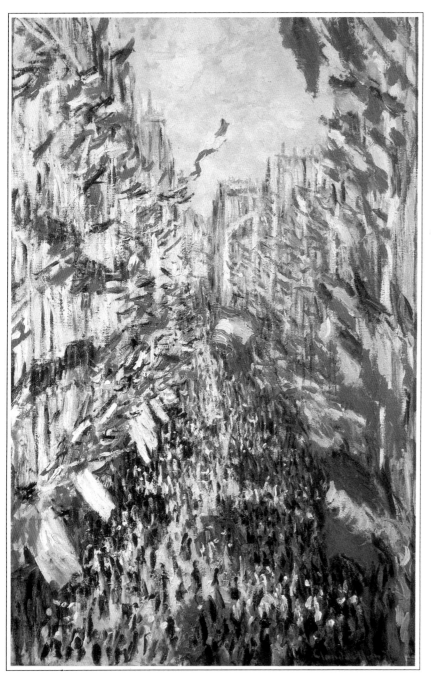

◁ **La Rue Montorgeuil, Festival of 30th June** 1878

Oil on canvas

THE IMPRESSIONISTS belonged to a new class of French people who had found a new freedom in the years of Napoleon III's reign. Street festivals celebrated the new optimistic feeling and the one on 30th June 1878 had a particular significance for it celebrated the opening of an International Exhibition which marked the renaissance of France after the disastrous defeat of 1870. Monet painted his impression of the joyful occasion from a balcony in Les Halles.

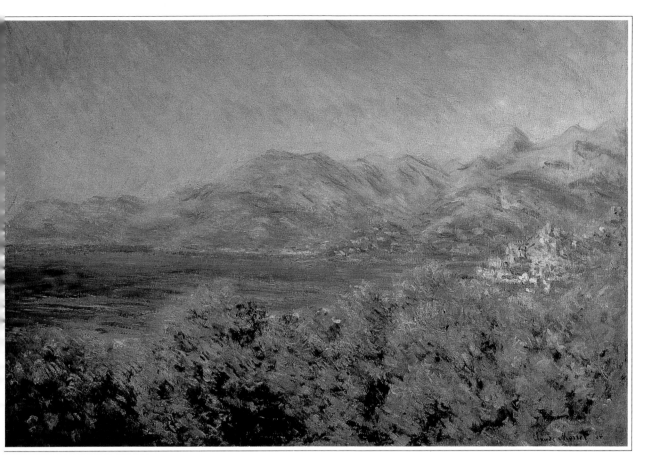

△ **Ventimiglia** 1884 Oil on canvas

WHEN MONET WENT to the Riviera in 1884 he found a very different light from the one that he was accustomed to in the north. Here, there were none of the subtleties of colour he had found in the fog of London, but instead the strident glare of sea and sky and a landscape full of violent contrasts. The burning sunshine, which inspired Van Gogh, also stimulated Monet to paint in a different kind of way. He wrote to Alice Hoschedé, 'People will protest that it is quite unreal, that I am out of my mind, but that is just too bad. Anyway, they say that when I paint our part of the world.'

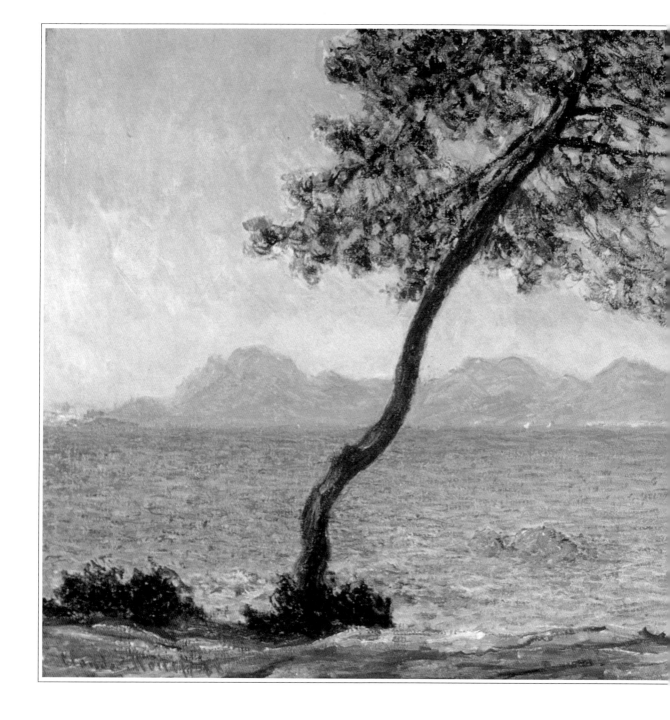

◁ **Antibes** 1884

Oil on canvas

THE OLD SEAPORT of Antibes, founded by the Greeks and used by Napoleon's fleet, had little topographical or historical interest for Monet. Instead, he chose a lonely part of the coast with a solitary pine tree as his theme. His real interest was the changing colour of the sea and the blue-violet mountains beyond. The tree serves as a foil for the distant scene, which is probably of the mountains towards the Italian border.

▷ **Storm: Rocks at Belle-Ile** 1886

Oil on canvas

THE ISLAND OF BELLE-ILE lies off the Quiberon peninsula on the Atlantic coast of France, its rocky coast buffeted by winds and waves. A visit by Monet to Belle-Ile in 1886 resulted in nearly 40 magnificent paintings, some painted by Monet on calm days with blue skies, but many in stormy weather with Monet braving the elements in his oilskin and sou'wester, laying strong red and blue tones on to canvases lashed by wind and stones. He wrote to his dealer, Paul Durand-Ruel, telling him that in the prevailing conditions he could not tell whether his paintings were any good or not, but that he would meditate on them in a moment of peace and add a few touches, if necessary, in the studio.

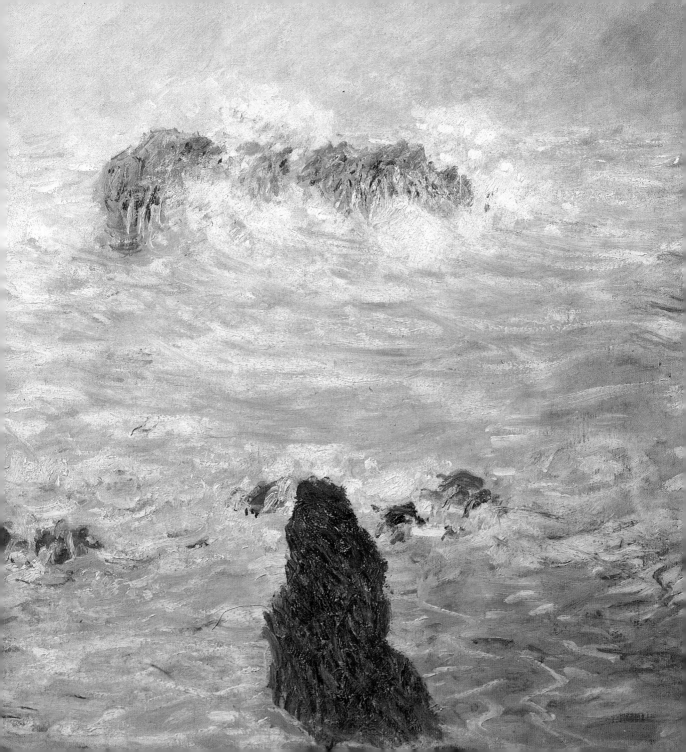

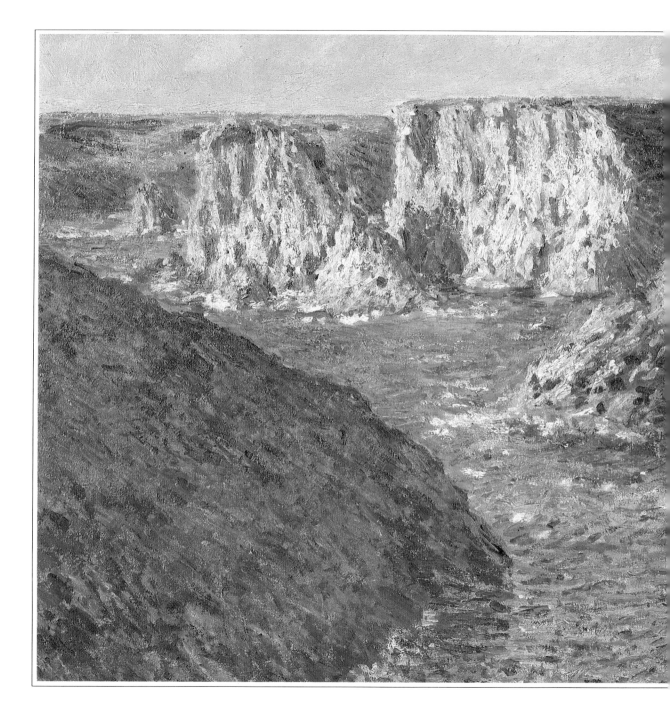

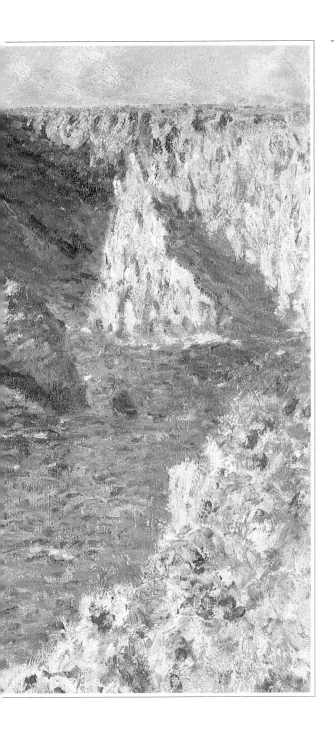

◁ **The Rocks
at Belle-Ile** 1886

Oil on canvas

ANOTHER PAINTING from the powerful series painted by Monet in 1886. Monet often complained that the adverse weather conditions made his work difficult when he was painting on the Atlantic coast island. For this painting the weather appears to have been kinder. Monet had been drawn to the sea as a subject from his youth. He had spent some time at Le Havre and had met Eugène Boudin, who had taken him on expeditions, painting direct from nature, along the nearby coast. The sea's restless nature also struck a chord in Monet's own character.

▷ **Woman with a Parasol** 1886

Oil on canvas

MONET PAINTED TWO versions of this delightful image of a lady with a parasol. In one, the girl – his second wife's daughter, Suzanne – faces to the artist's right; in the other she faces to his left. When Monet painted these pictures of Suzanne he was perhaps thinking of his first wife, Camille, whom he had painted in a similar pose some 10 years before when they lived in Argenteuil. Camille had died in 1879, after giving birth to their second son.

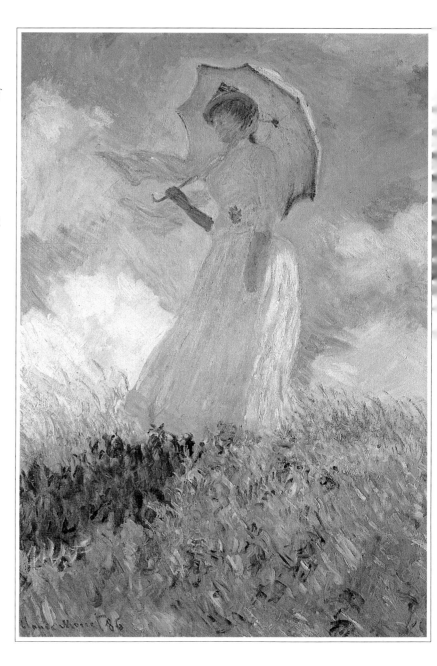

▷ **Blanche Monet Painting** 1887

Oil on canvas

BLANCHE WAS THE daughter of Alice Hoschedé and, like her mother, she admired Monet's work. She had ambitions to become a painter herself. The other girl in the picture is her sister Suzanne, of whom Monet had painted the two paintings of the woman with a parasol. Blanche began painting in 1882 at Pourville where Monet himself had first worked and became a talented disciple of her stepfather. She married Monet's son, Jean, but gave up painting after her husband died, taking it up again on Monet's death in 1926.

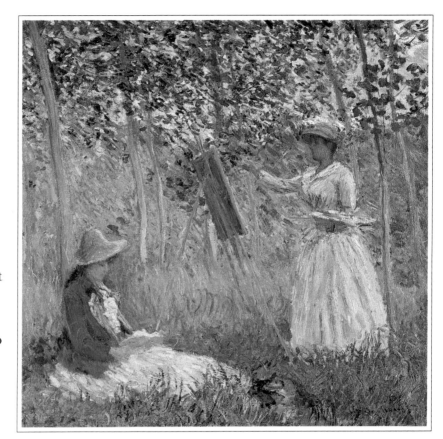

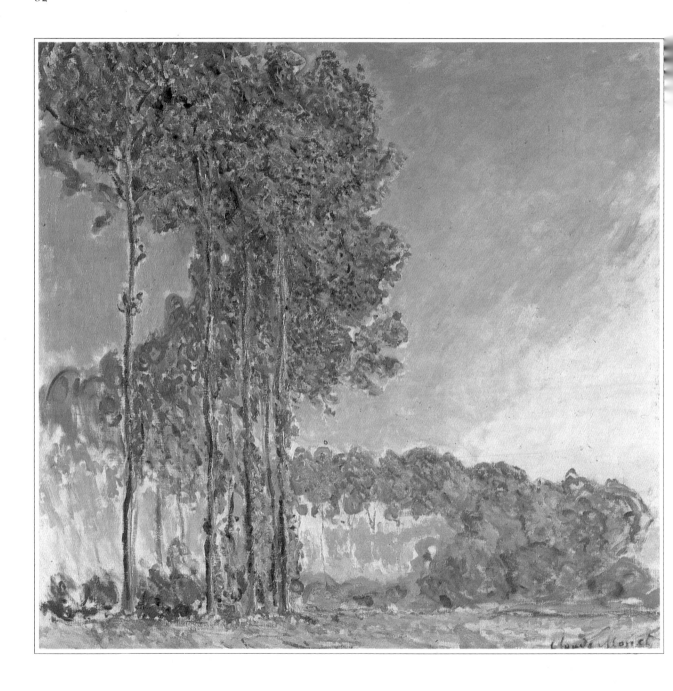

◁ **Poplars** 1890

Oil on canvas

THE POPLAR SERIES WAS another of Monet's voyages of discovery of the reality lying behind superficial visual appearances. He painted the tall trees on the banks of the Epte, near Giverny, over several months in 1890 and 1891, often with as many as ten canvasses in work at once. Like the haystacks series, the poplar series proved very successful, selling quickly and for high prices. They had caused less tension in the painter than the Rouen Cathedral series, perhaps because they were in close affinity with their countryside context and atmosphere.

▽ **Haystacks at Sunset, Frosty Weather** 1890

Oil on canvas

MONET'S PASSION FOR painting series of works of the same subject in different lights began in 1891 with haystacks and poplars. By now, he had become known and comparatively well-off, and could allow himself the luxury of painting for the sake of the painting itself and not because the subject might appeal to a buyer. Painting was a language for the interpretation of visual reality and Monet's series paintings are an exploration of that language. Talking to his friend Georges Clemenceau, he tried to explain that while the statesman was the kind of person who wanted to impose on the world his own concept of it, he, Monet, was simply trying to explore reality – 'or at least, what we know of it.'

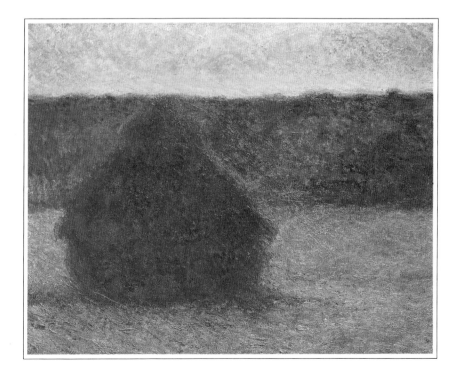

▷ **Cathedral at Rouen: Harmony in Blue and Gold** 1894

Oil on canvas

The Rouen Cathedral series which Monet began in 1892 was dogged by bad weather. Nevertheless, over the several months he worked in Rouen he produced some 200 sketches, drawings and finished oil paintings which show the light at different times of day and in different weather on the façade of the great church. Writing to Alice, now his wife, he said, 'I'm working like a madman, but alas, all your words are in vain. I feel empty and good for nothing. I'm very much afraid I will leave everything and come home on impulse.' In the end, the series was not ready for exhibition until 1895.

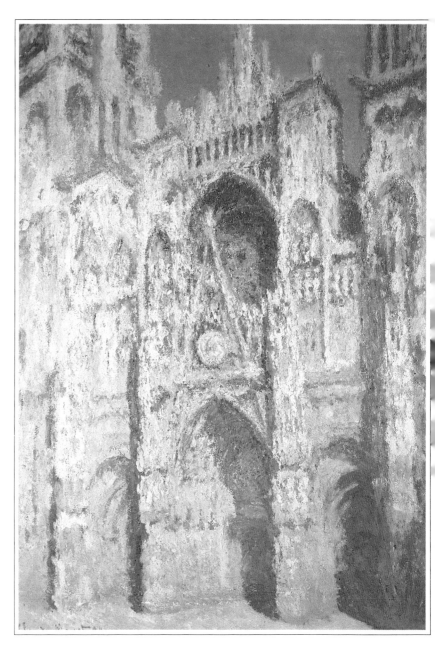

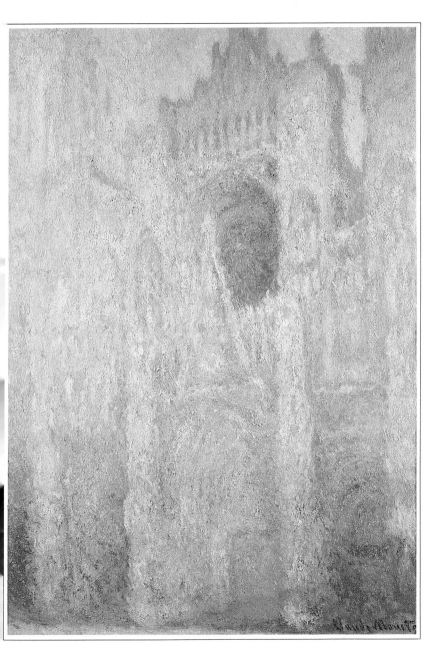

◁ **Rouen Cathedral** 1894

Oil on canvas

Painting Rouen Cathedral at different times of the day and seasons of the year might be said to have become an obsession with Monet. It was not the Cathedral itself that fascinated him so much as the play of light on its façade. In order to work undisturbed, in 1892 Monet took a room above a shop, from where he could view the cathedral and work on several canvasses at once, switching from one to the other as the light and weather conditions changed. He was to return to Rouen in 1893, but did not complete his cathedral series – some 30 paintings – until 1895.

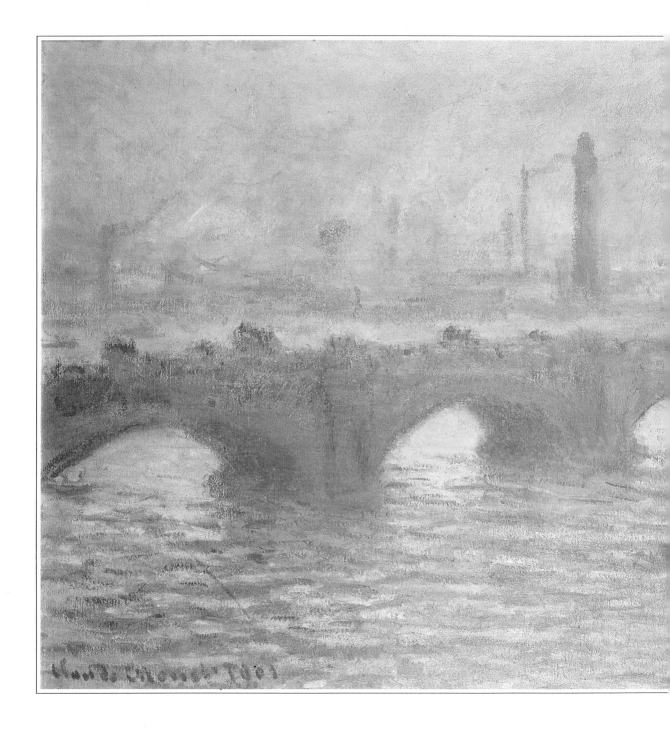

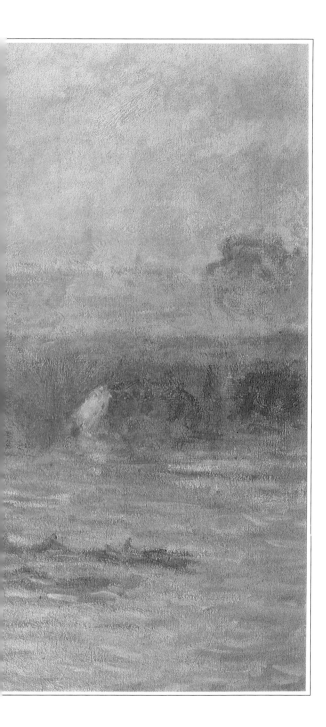

◁ **Waterloo Bridge** 1900

Oil on canvas

Monet made several visits to London, first in 1870-1, during the Franco-Prussian War, and several times later at the turn of the century, partly because his son Michel was in England, learning the language. He retained a considerable affection for the city, partly because of the atmosphere of mists, fogginess, and – sometimes – 'mellow fruitfulness' which would hang over the city and its great river. He stayed at the Savoy Hotel, where the view from the window stretched up-river to the Houses of Parliament and Westminster Bridge, and downstream to Waterloo Bridge and beyond. He painted about a hundred London pictures in all, most of them begun in London, but many finished in his studio back home in France.

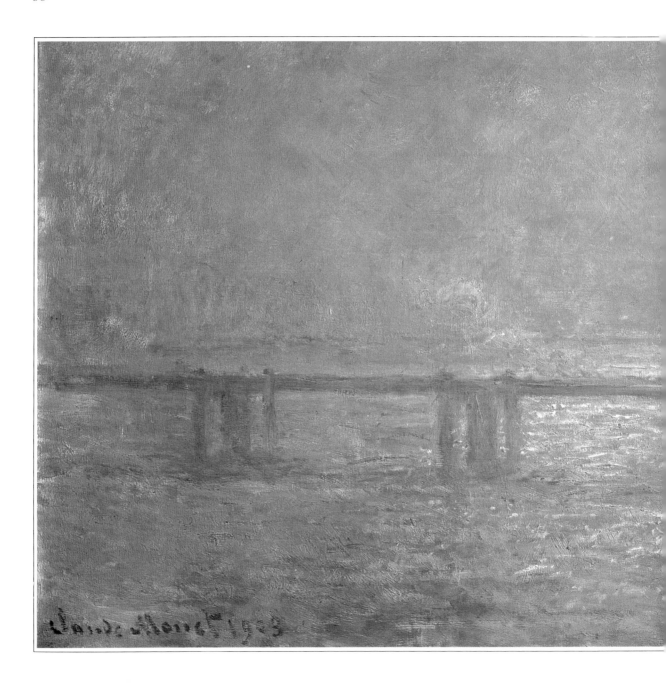

◁ **The Thames at Charing Cross** 1903

Oil on canvas

Despite his complaints about the English weather Monet returned to London a number of times after his first visit in 1870. 1903, when he painted this picture of the Thames at Charing Cross, was particularly disastrous as far as weather was concerned. It rained incessantly, and so hard that Monet complained he could not see through the window of his room at the Savoy, from where he was viewing the scene. Nevertheless, during his various visits he managed to do over 100 paintings and sketches.

▷ **Charing Cross Bridge** 1904

Oil on canvas

The Impressionist eye, seeing a picture as a whole and sublimating detail to the demands of colour and harmony, made even mundane structures – like this railway bridge across the Thames – into magical constructions. The smoke and fog of the days of coal fires helped to provide a romantic haze, and the bustle and noise of the river, with its lighters and barges gathering round the cargo steamers, made the whole scene an inspiration for painters.

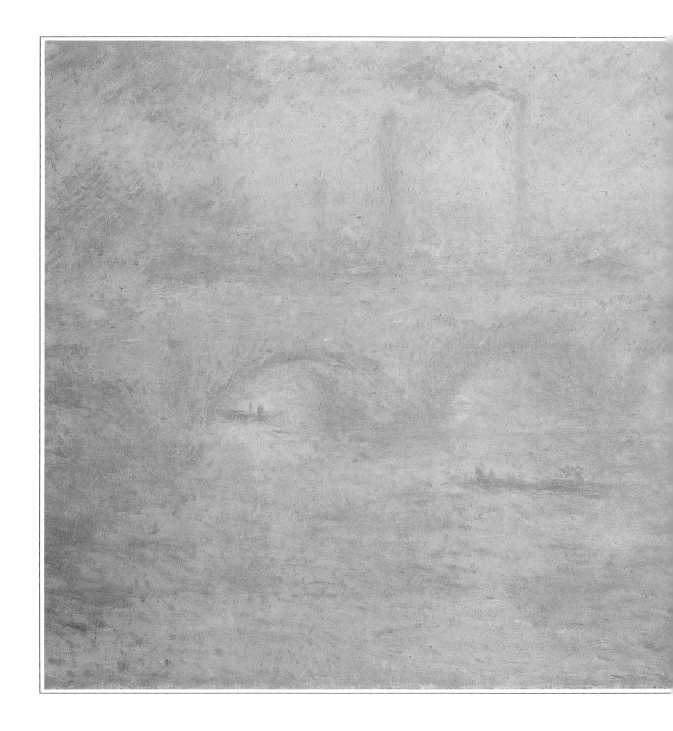

◁ **Waterloo Bridge: Effect of the Mist** 1904

Oil on canvas

London is lucky to have received so many visits from Monet, for he gave Londoners a new and romantic view of their city at a time when it seemed a grimy, fog-bound seaport with a river clogged by barges and small steamers. There was romance in that, too, of course, for London was the heart of Empire, the seat of the greatest power on earth, and a headquarters of world trade. For Monet, all this was less important than the subtle colour effects produced by the changeable weather on the Thames and its bridges, and the surrounding buildings.

▷ **The Houses of Parliament, Orange Sky** 1904

Oil on canvas

Monet painted the Houses of Parliament in London many times on numerous visits. He was often irritated by the weather, which was so changeable that he could never paint the same canvas two days running. He had come to accept the London fogs, however, and once wrote to Gimpel, the art dealer, that the fog gave the building 'its marvellous breadth. Its regular massive blocks become grandiose in this mysterious cloak.'

His approach to depicting the 'mother of Parliaments' changed over the years, the Whistlerian silhouettes of the 1870s giving way to an almost violent use of dense, strong colours that prefigured the Fauves.

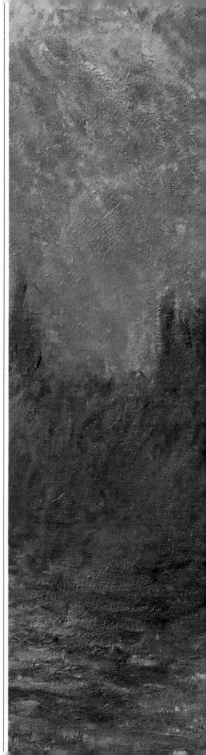

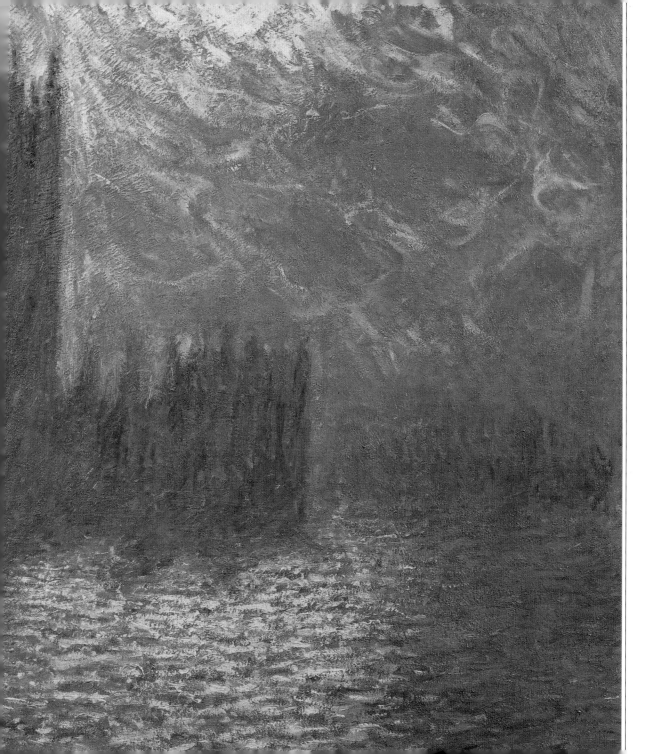

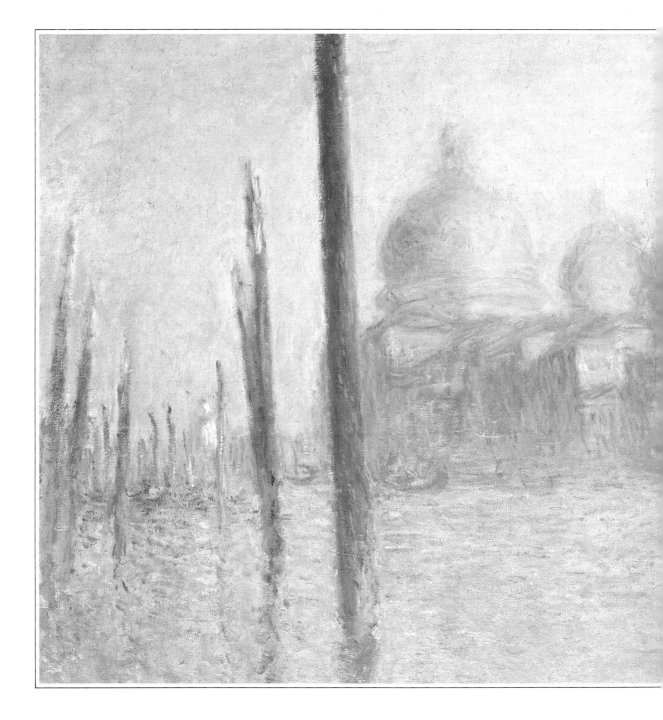

◁ The Grand Canal, Venice 1908

Oil on canvas

Monet visited Venice in 1908, by which time he was an established artist with his own individual style. In spite of this, Monet never became complacent but was always looking for the final answer to that elusive truth about visual reality which motivated his painting. Venice was an eye-opener, with its shimmering light and extravagant abundance of colour reflected off buildings, and later gave him a whole new field of study. He would have liked to stay longer but was engaged in other work at Giverny. He wrote to his dealer Durand-Ruel: 'What a shame that I did not come here as a young man.'

Regatta at Argenteuil 1874

Oil on canvas

ARGENTEUIL, on the Seine north of Paris, was a happy place for Monet and his wife and their many painter friends, and 1874 was a particularly productive year out of the seven the Monets lived there. The atmosphere of the place, rebuilt after being caught up in the Franco-Prussian War, was light-hearted and the river banks lively with boating places and restaurants. It seemed to inspire Monet and his friends, Monet, in particular, producing pictures of artistic brilliance, wonderfully varied in subject and treatment. This painting of sailing boats on the Seine is a particularly fine example of Monet's work at the time. The Impressionists' idea of using colours as pure as possible, applying them in clean, decisive brushstrokes, is explored here in a boldly simplified style which is both fresh and natural: one can almost feel the placid rippling of the water's surface in the long, clean strokes of colour in the foreground of the painting.

Detail

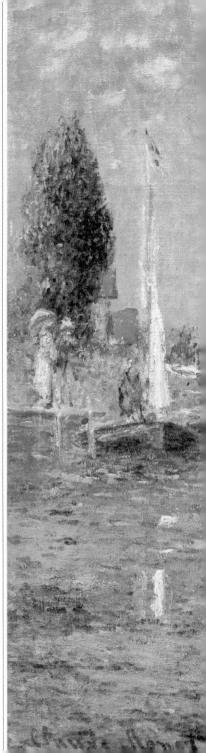

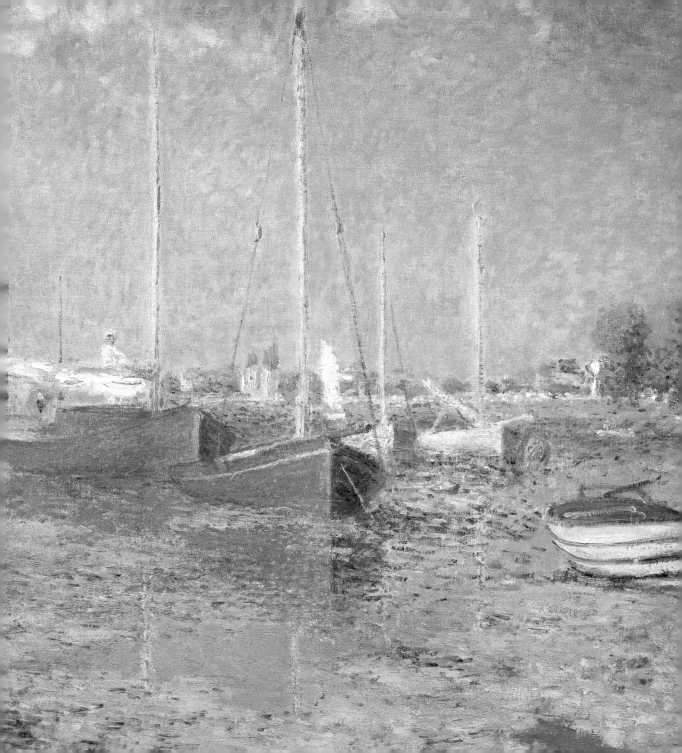

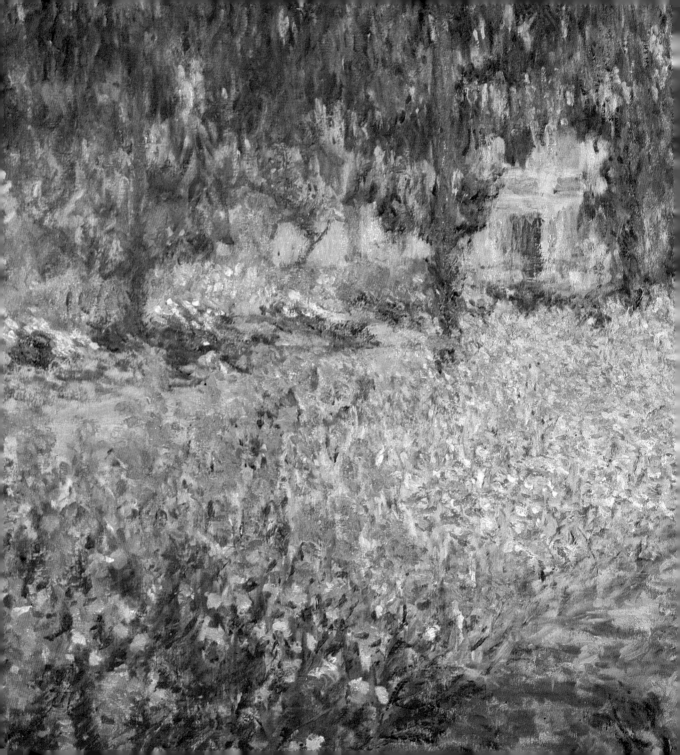

◁ **The Artist's Garden at Giverny** 1908

Oil on canvas

Irises were among Monet's favourite flowers and he went to a great deal of trouble to get the best bulbs for his garden, even importing special varieties from Japan.
These were handed to his gardener with careful written instructions on where to plant them and how to look after them. Apart from their botanical interest, Monet saw them as models for his paintings, either in great banks of colour or in single stems. As with his waterlilly pond paintings, Monet was totally committed at this period of his life to the exploration of colour combinations in which each brushstroke was like a note in a piece of music.
Its intensity and tone were in complete balance with every other brushstroke, thus creating a perfect composition.

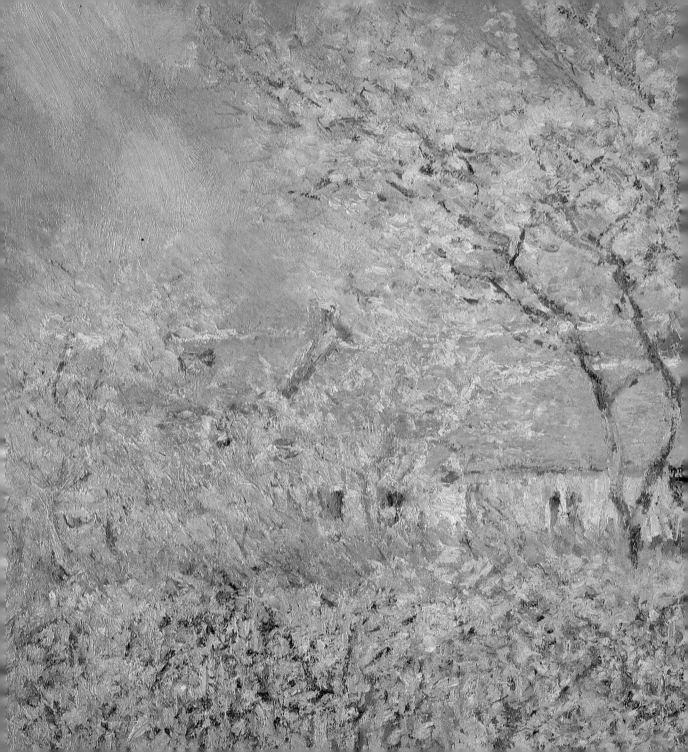

◁ **Springtime at Giverny** 1908

Oil on canvas

Monet's garden at Giverny was a riot of colour in springtime, as he took good care to buy the necessary flower bulbs and instructed his gardeners how, when and where to plant them. Spring was a good time to paint his creation and he did so with enthusiasm and liberal use of colour, though always controlled and carefully applied so that the paintings retained their freshness, and look as clear and lively today as when they were painted. In this painting he has contrasted the red roofs of the buildings and the more delicate pink of the blossom with the greens of the foreground and the blue of the sky. Monet had several studies in his garden, including one large enough to take the great waterlilly paintings now owned by the French state.

▷ **The Garden at Giverny** 1908

Oil on canvas

Monet first rented the house and garden at Giverny, a small village where the river Epte and the Seine joined, early in the 1880s. At the time, it was a simple, rather primitive cottage. Today its beautiful gardens, enlarged when Monet bought the property in 1892, with its various outhouses, studios and greenhouses, have become a place of pilgrimage for all lovers of art. There they find a garden romantically disarrayed, full of clumps of flowers planted by the painter to ensure for himself an endless vista of subjects for his paintings. By the end of his life, Monet's garden at Giverny was his sole inspiration; he would even say, in moments of despair at the way his paintings did not turn out as he imagined them, that his garden was his true masterpiece.

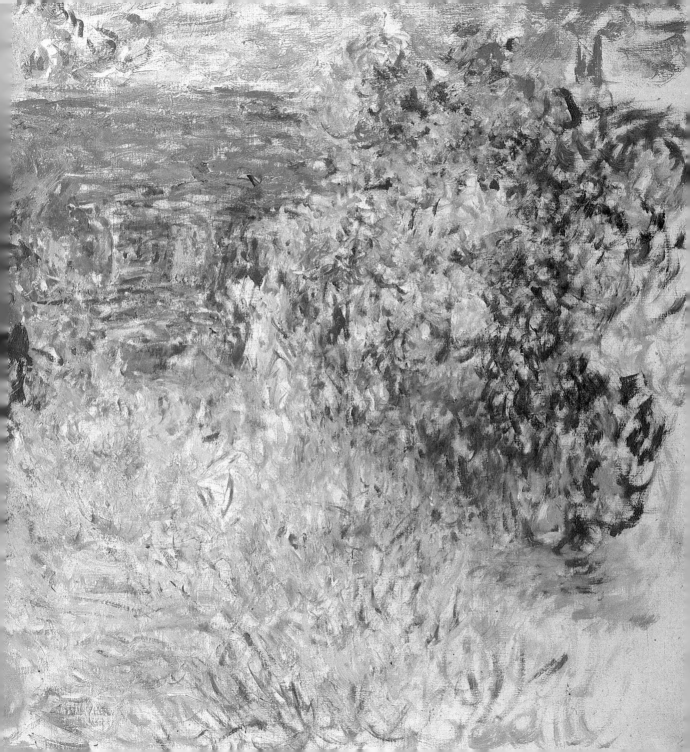

▷ **Water-lilies: Japanese Bridge** 1908

Oil on canvas

This is perhaps one of the most adventurous of the voyages of discovery into the world of colour that Monet made in the last years of his life. He was now totally dedicated to the langauge of colour, to finding the exact brushstroke which would harmonize or contrast with other brushstrokes and create a perfect balance and which, when achieved, would become the perfect work of art, a reality in its own right. In his pursuit of this, Monet worked ever more deliberately and destroyed paintings (30 of the water-lily series alone) that did not satisfy him.

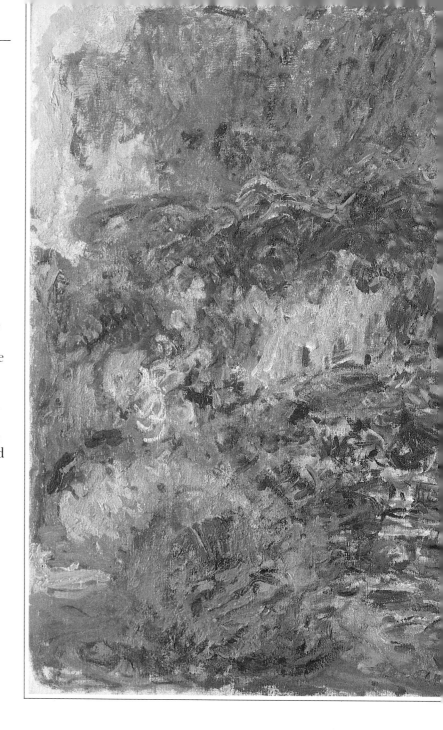

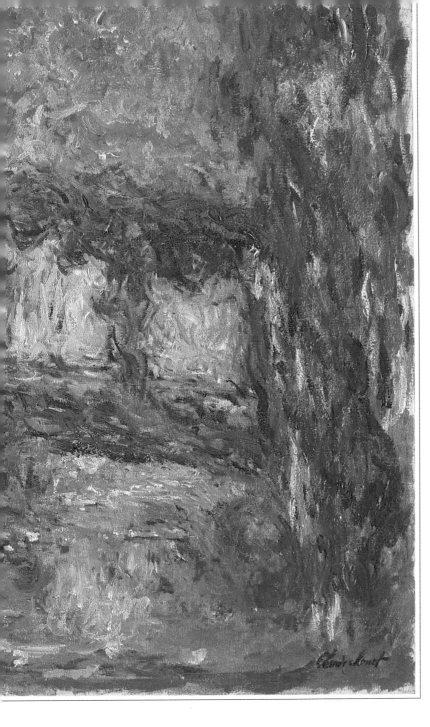

Study of Water–lilies 1908

Oil on canvas

▷ *Overleaf page 78*

Some 249 paintings of water–lilies have been recorded among Monet's prodigious output. They are to be found in art galleries all over the world. The greatest sequence was one of 19 vast canvases undertaken during World War I at the persuasion of his old friend Georges Clemenceau, known as 'the Tiger', the French statesman who presided at the peace conference at the end of World War I. Monet's idea was to paint a series of water–lilies large enough to encircle the rotunda of the Salon, enclosing the spectator on all sides. The war over, Monet offered his great project, not yet complete, to the French nation, Clemenceau acting as intermediary. It may now be seen in Paris, along with many studies for the beautiful flowers.

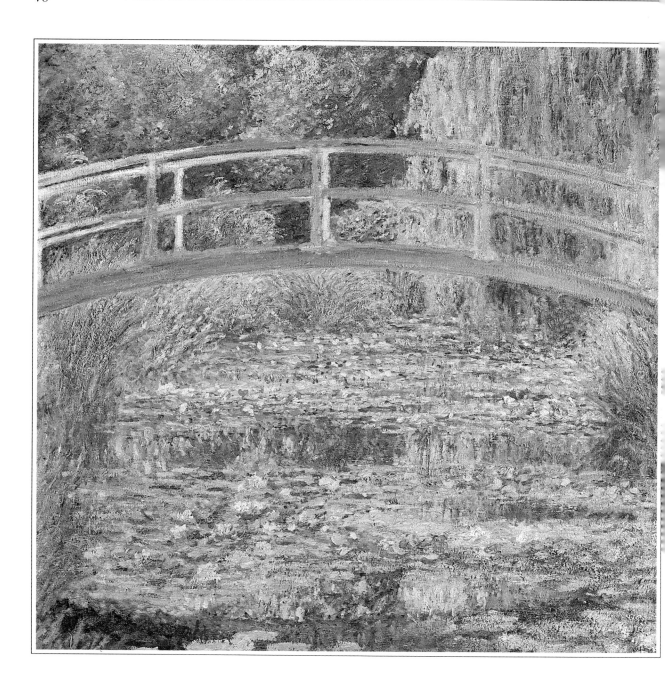

ACKNOWLEDGEMENTS

The Publisher would like to thank the following for their kind permission to reproduce the paintings in this book:

The Fine Art Museums of San Francisco, Gift of Osgood Hooker, 1960.29, 66-7; **Kimbell Art Museum, Fort Worth, Texas** 8-9; **Musée Marmottan, Paris** 28-29; **Reproduced by courtesy of the Trustees, National Gallery, London** 19.

Bridgeman Art Library, London /Christie's, London 36-37, 37, 40-41, 55, 56-57, 60-61, 72-73, 74-75; /**Courtauld Institute Galleries, University of London** 44-45; /**Fitzwilliam Museum, University of Cambridge** 52; /**Glasgow City Art Gallery and Museum** 43; /**Giraudon/Boston Museum of Fine Arts, Mass.** 38; /**Giraudon /Kunsthalle, Bremen** 12; /**Giraudon/Louvre, Paris** 13,33, 34-35; /**Giraudon Musée des Beaux-Arts, Lyons** 58-59; /**Giraudon/Musée des L'Orangerie, Paris** 68, 68-69; /**Giraudon /Musée d'Orsay, Paris** 14,20, 30-31, 32, 39, 42, 54, 70-71; /**Giraudon/Walters Art Gallery, Baltimore, Maryland** 21; /**Hermitage, St Petersburg** 62-63; /**Kunsthalle, Hamburg** 11; /**Lauros-Giraudon /Musée des Beaux-Arts, Lille** 64-65; /**Los Angeles County Museum of Art** 51; /**Louvre, Paris** 24-25; /**Minneapolis Society of Fine Arts, Minnesota, USA** 76-77; /Musee des Beaux-Arts, Le Havre 26-27; /**Musée d'Orsay, Paris** 10, 46-47, 50; /**Musée St Denis, Reims** 48-49; /**National Gallery, London** 16-17, 22-23, 78; /**National Gallery of Art, Washington** 18; /**Private Collection** 53; /**Pushkin Museum, Moscow** 15, 30.